POOPING ANIMALS

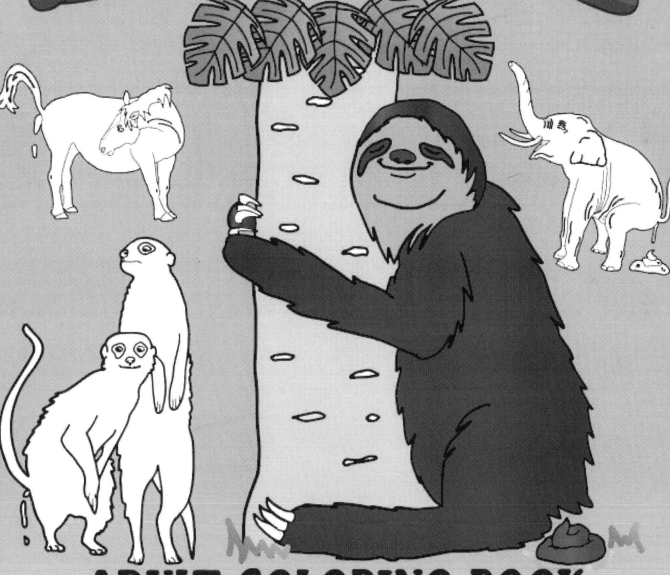

ADULT COLORING BOOK

Published in 2018 by
What the Farce Publishing

Copyright Illustrations © 2018 by What the Farce Publishing
All rights reserved. No part of this publication may be reproduced or transmitted
in any form or by any means, electronic, or mechanical, including photocopy,
recording or any information storage system and retrieval system without
permission in writing by Publisher What the Farce.

Printed in the United States of America

Watch out for a bears first "number two" after sleeping all winter, because bears don't poop when they hibernate!

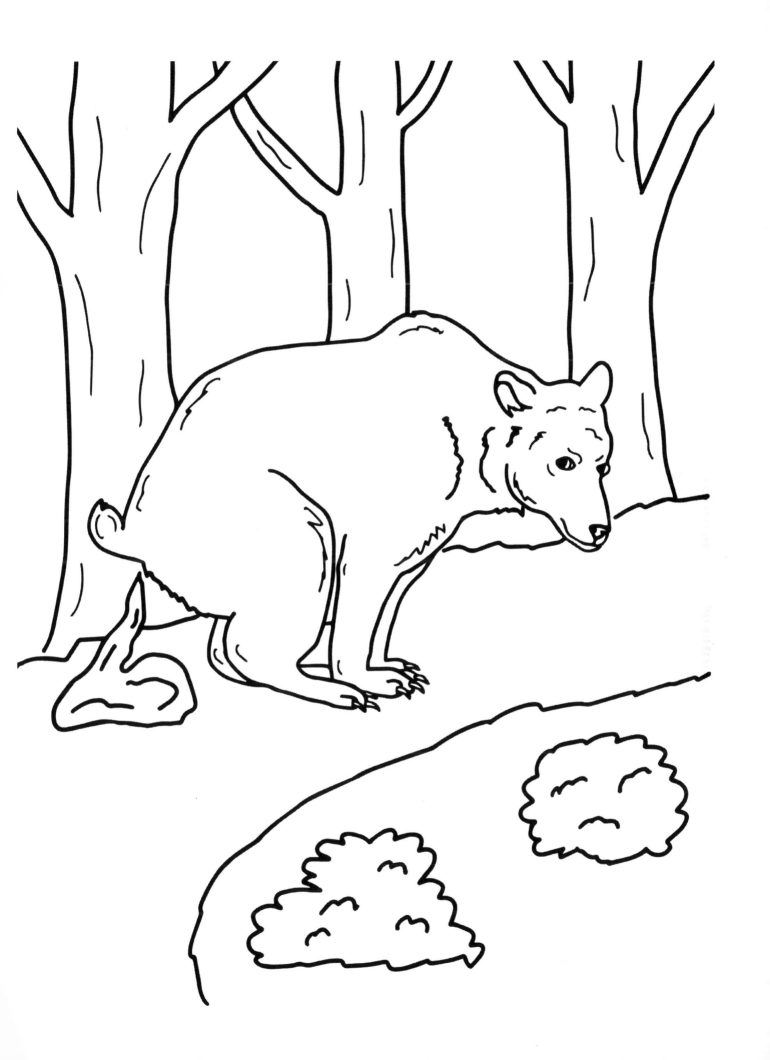

Elephants can poop up to 300 pounds a day!

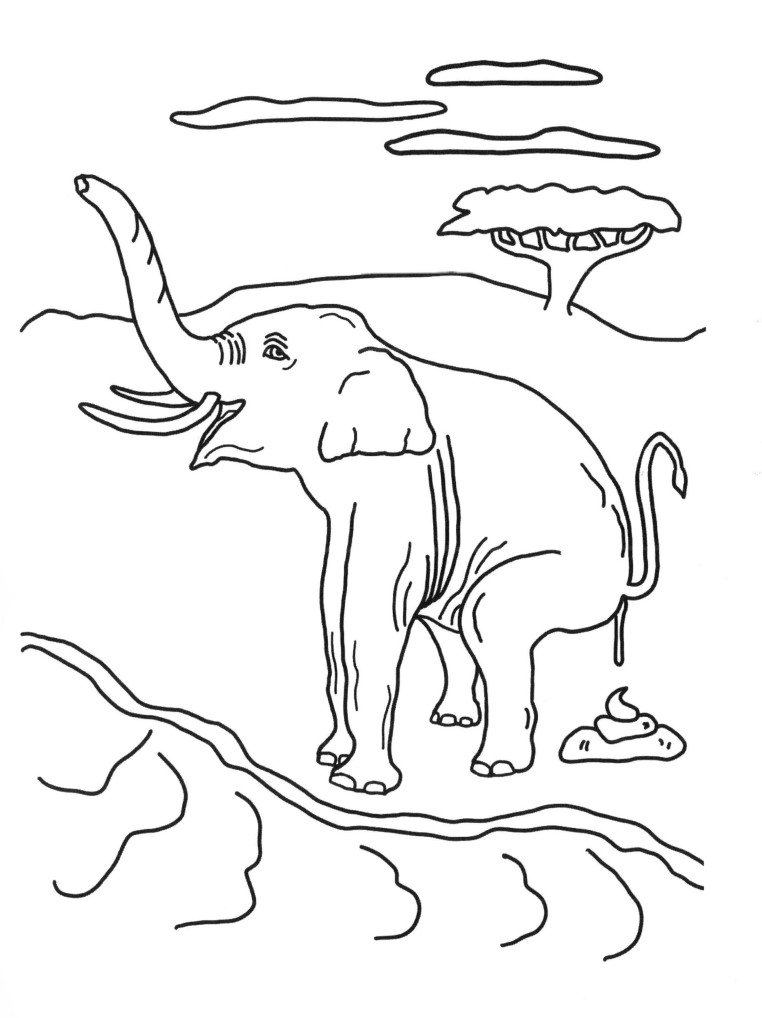

Caution! Hippos spin their tails to launch their poop!

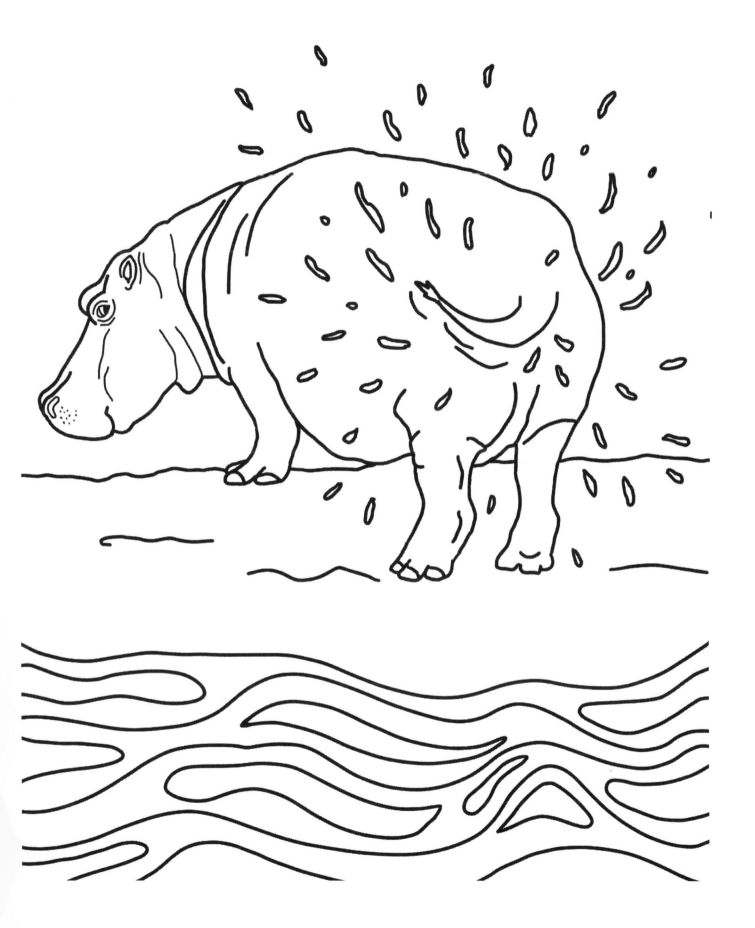

It's fun to poop when you're standing up!

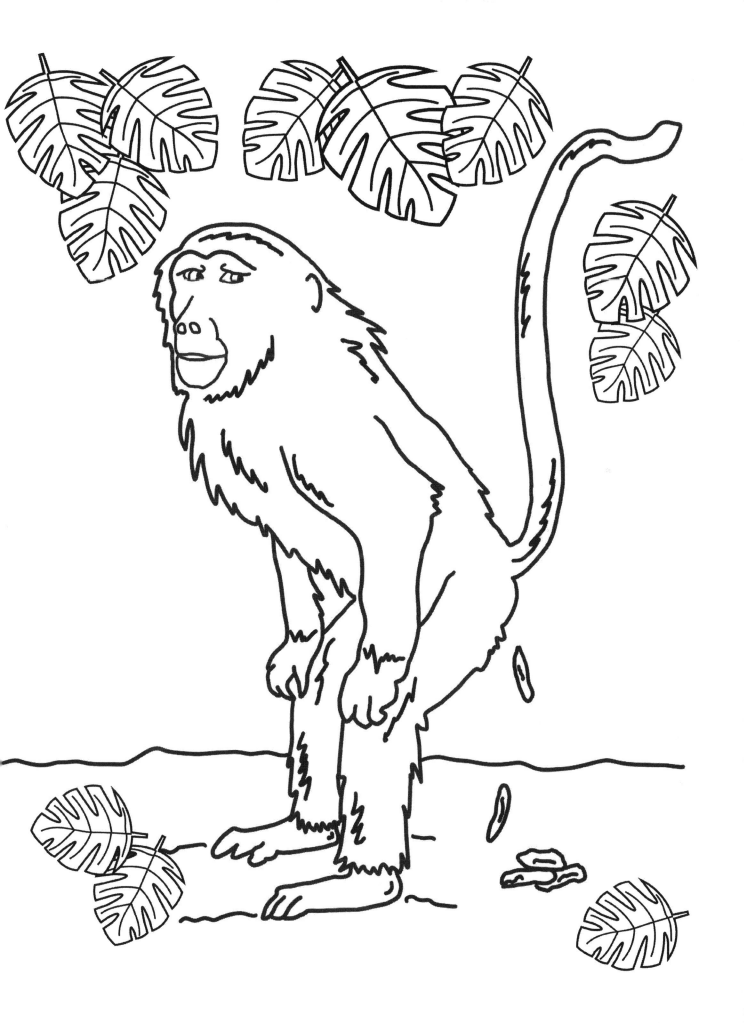

Whales have the biggest poop in the world!

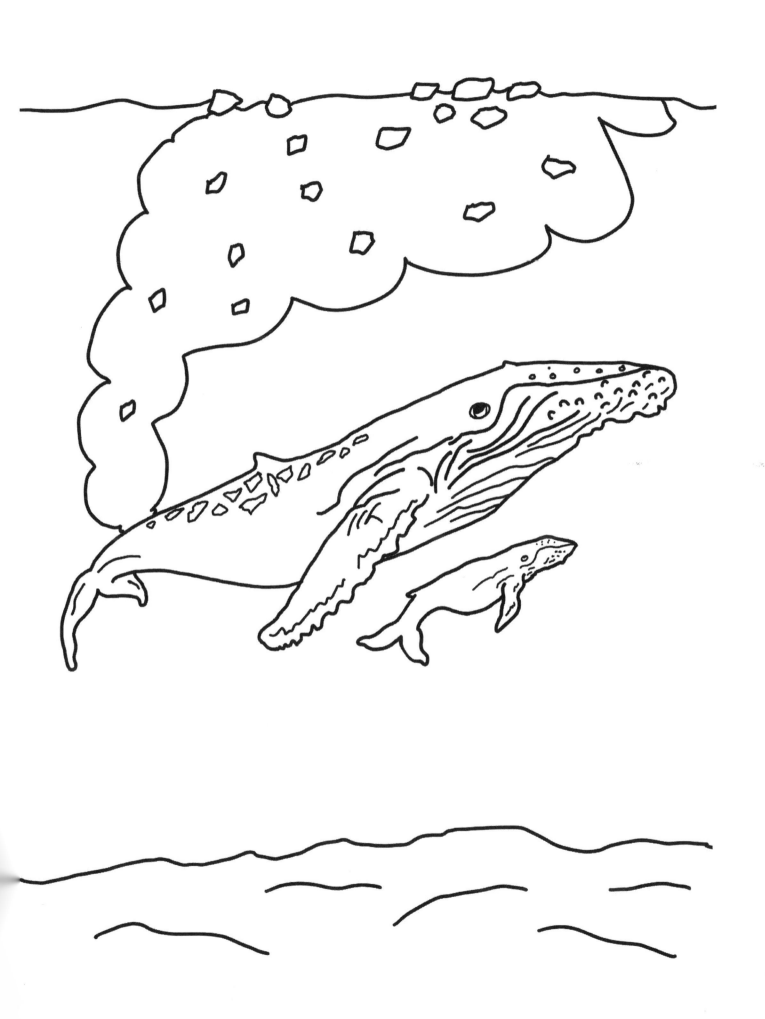

Every Sloth does a "Poo Dance" before he poops!

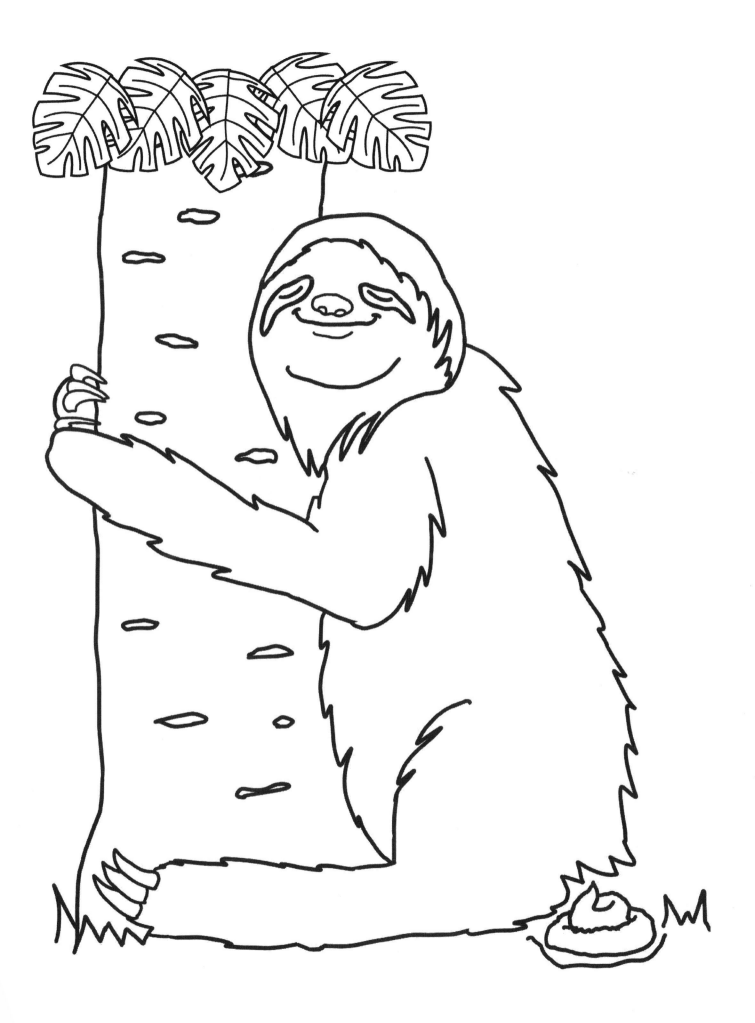

You never know what you're going to see in goat poop, because they eat everything!

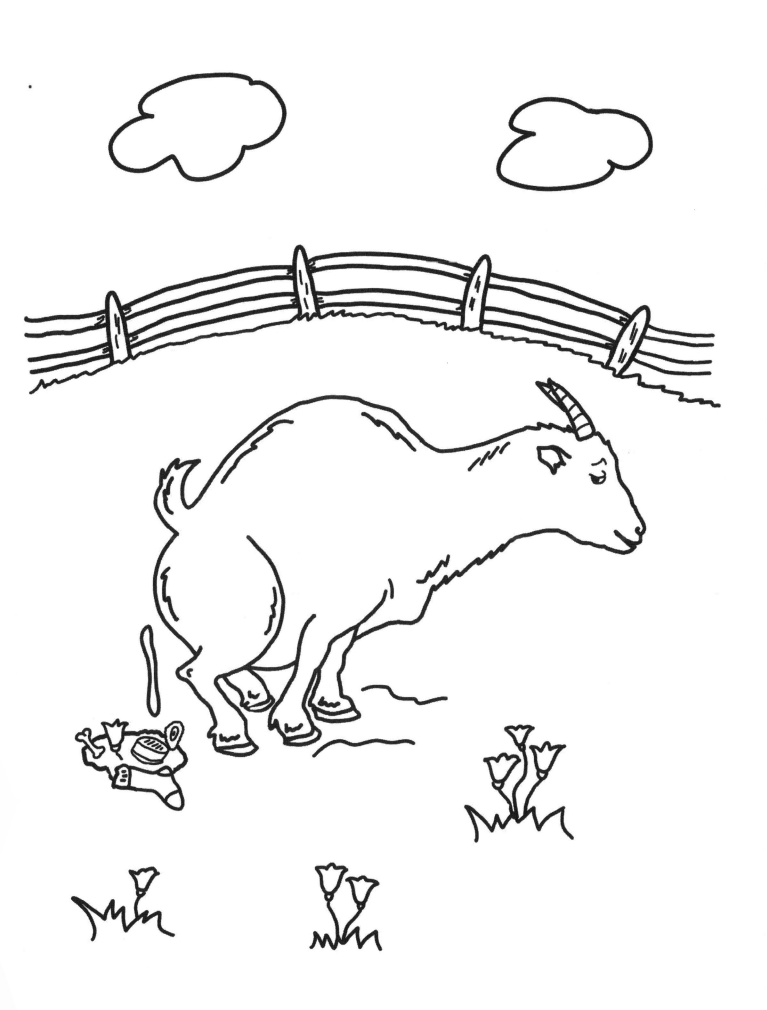

Foxes have musky smelling poop!

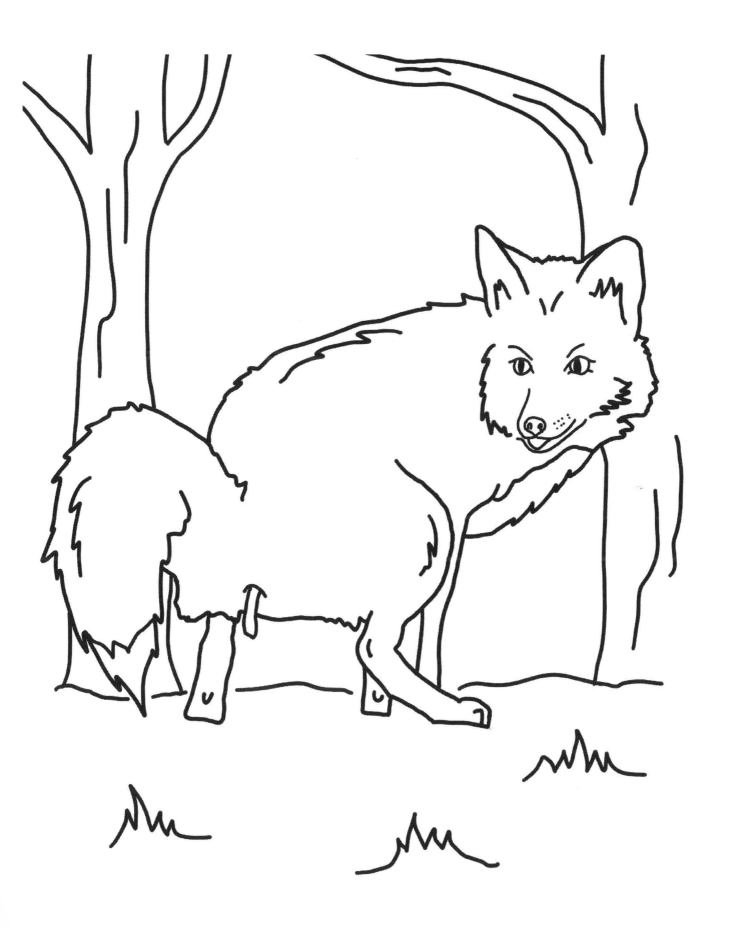

Meerkats had public toilets before humans!

Penguins launch their poop!

Rabbits eat their own poop!

Panda bears poop out lots of bamboo!

Kangaroos can hop and poop at the same time!

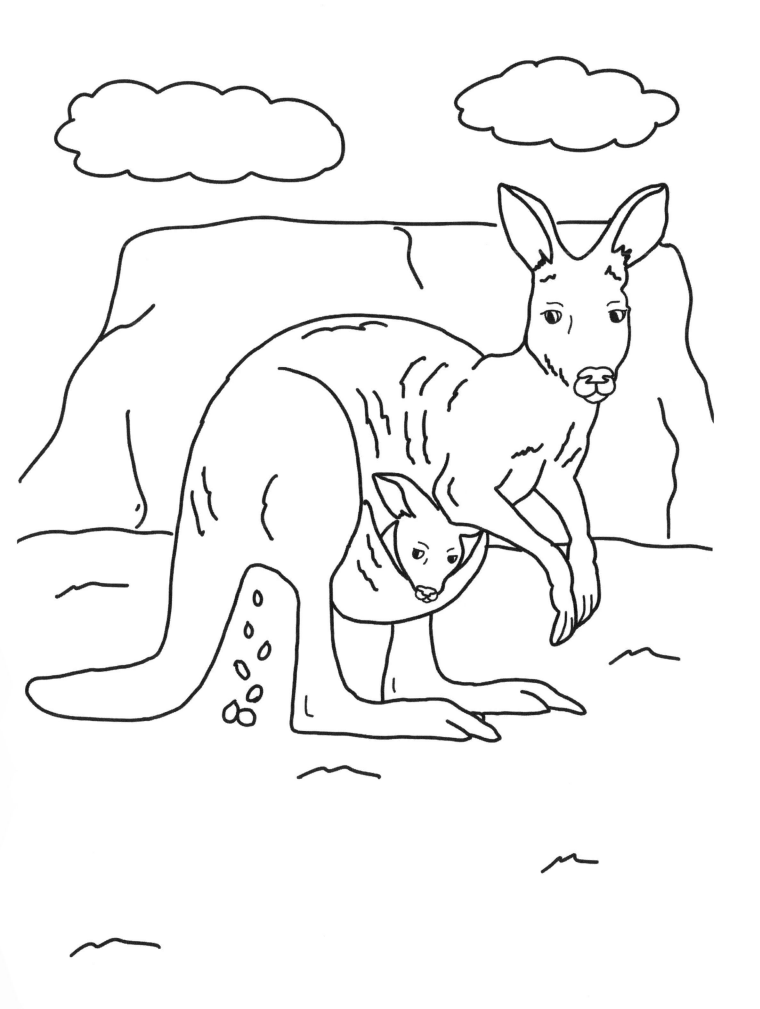

Watch out, monkeys like to throw their poop!

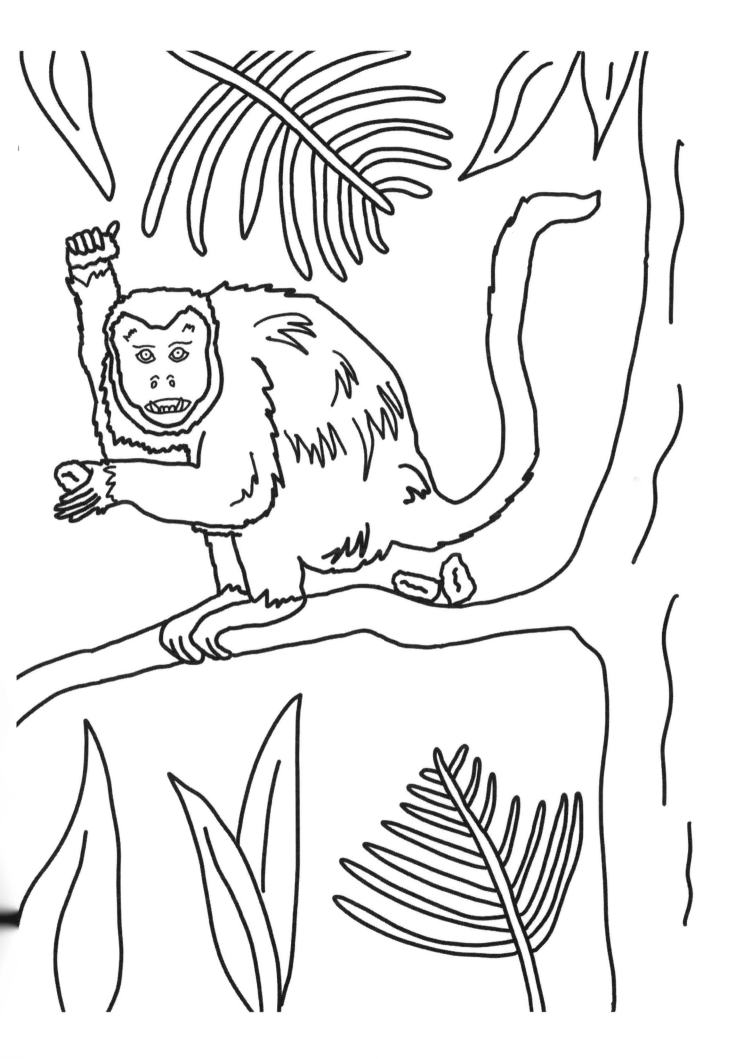

Llama poop fights water pollution!

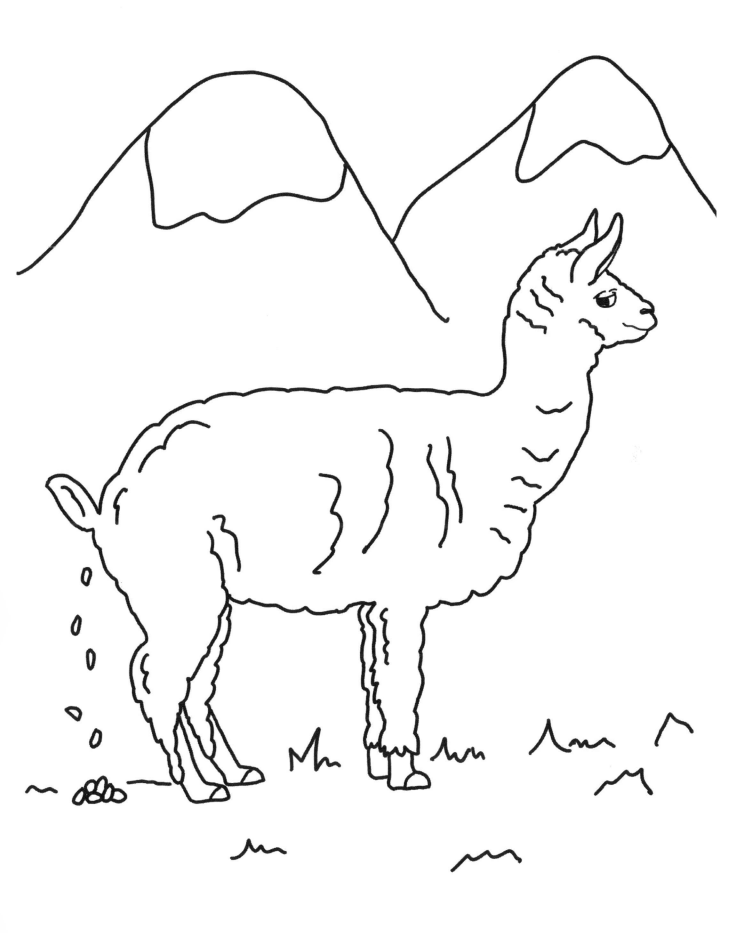

Deer leave big piles of pellet poop!

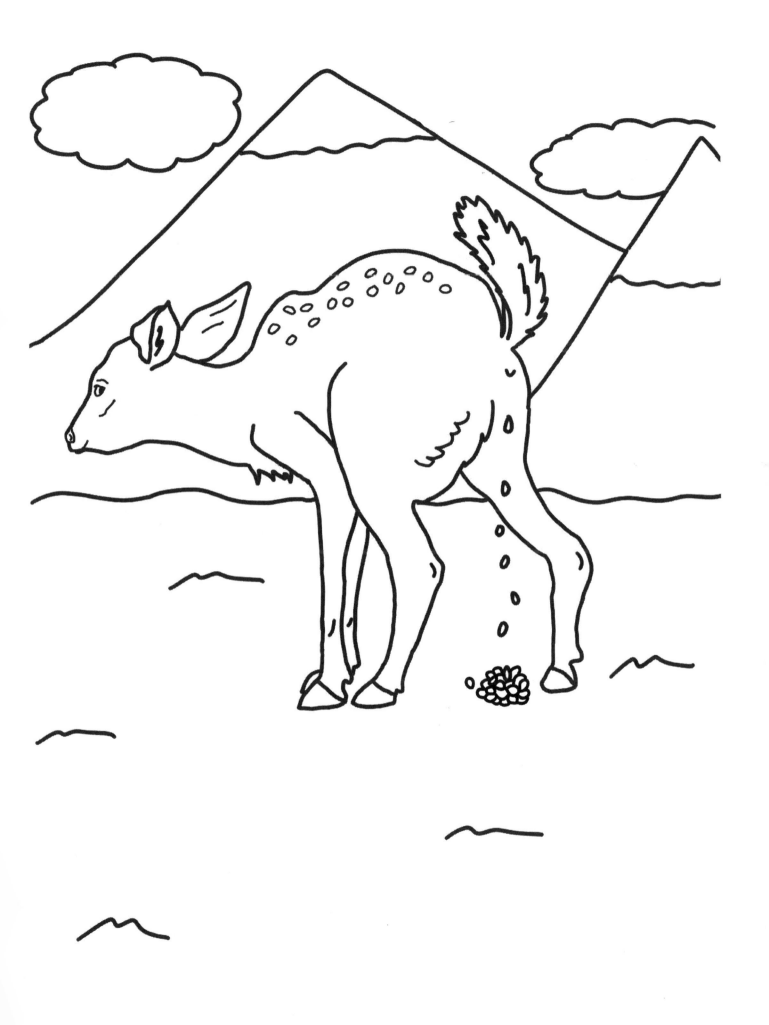

Australian Shepherds like to squat & walk while they poop, leaving a trail of gifts for their owners!

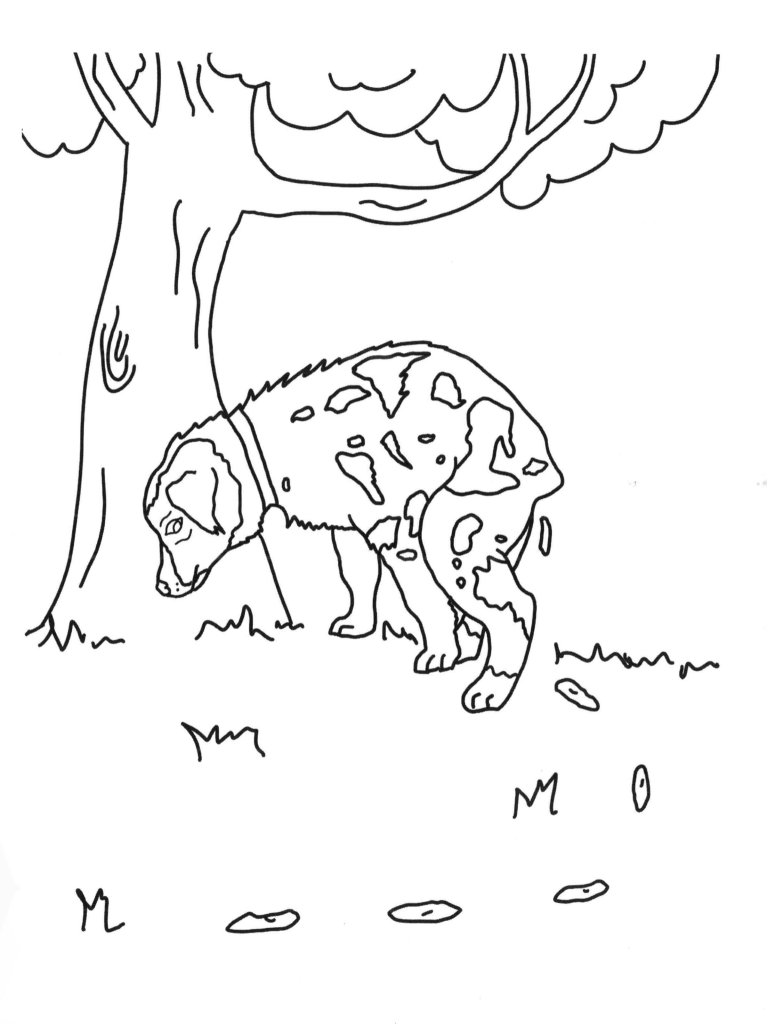

Parrot Fish poop sand for our beaches in Hawaii!

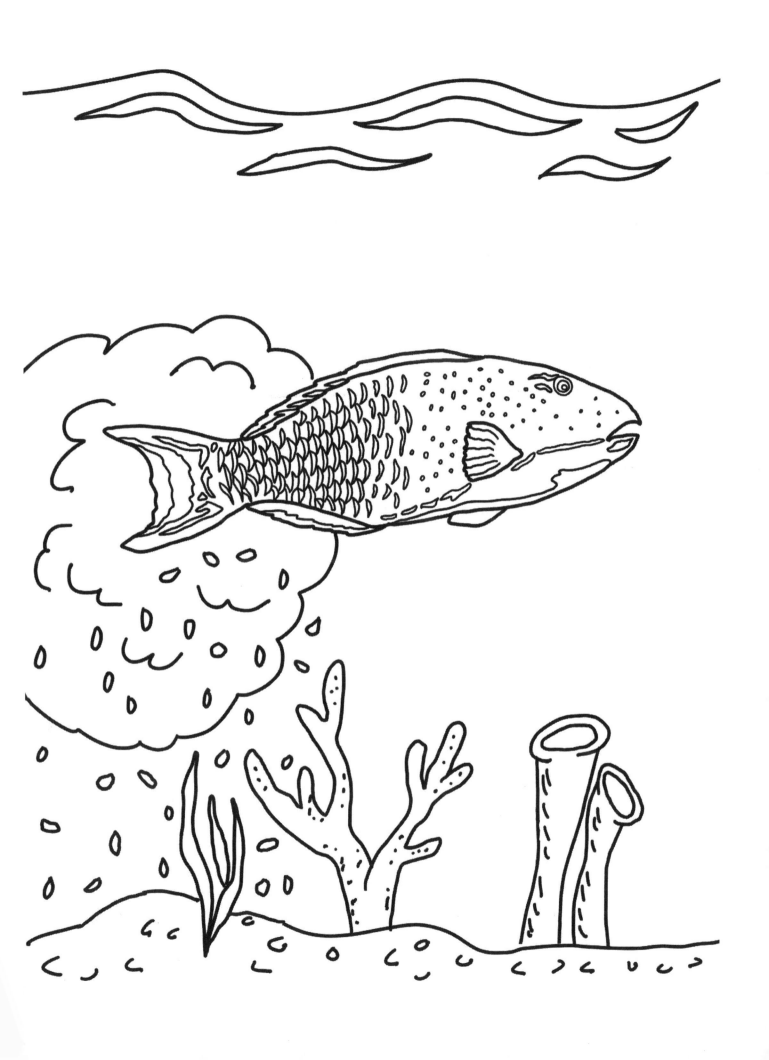

Zebras poop is full of grass, that's what happens
when you eat too fast!

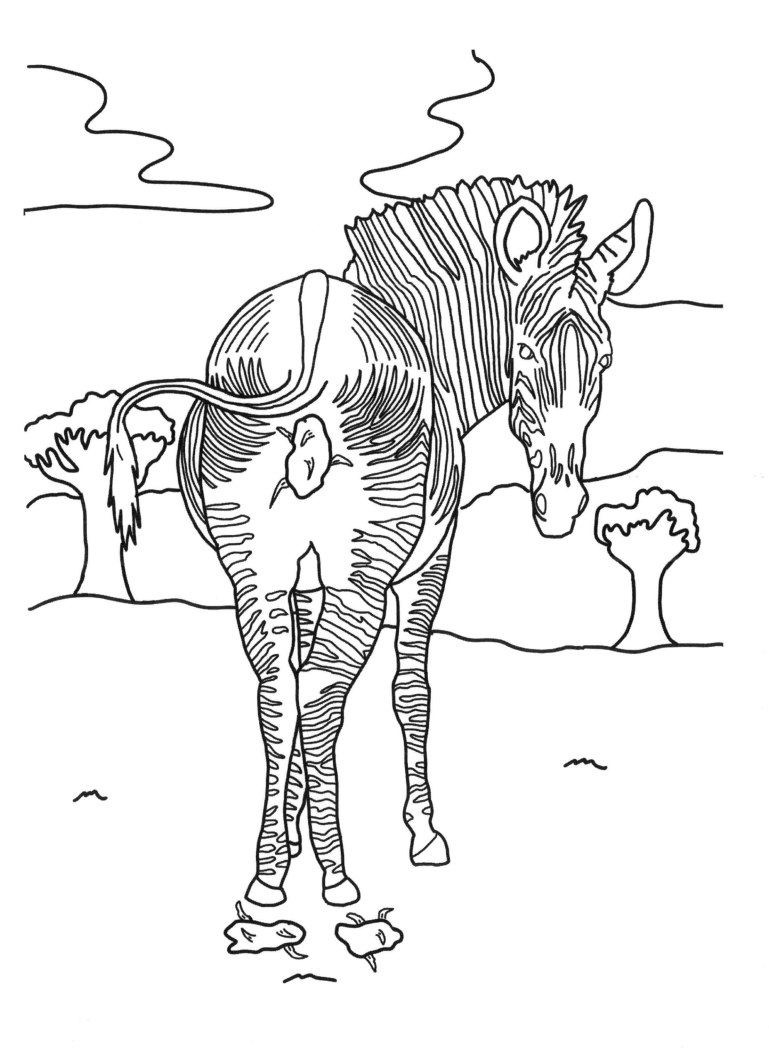

Stallions in a herd will all poop in the same place, no horsing around there!

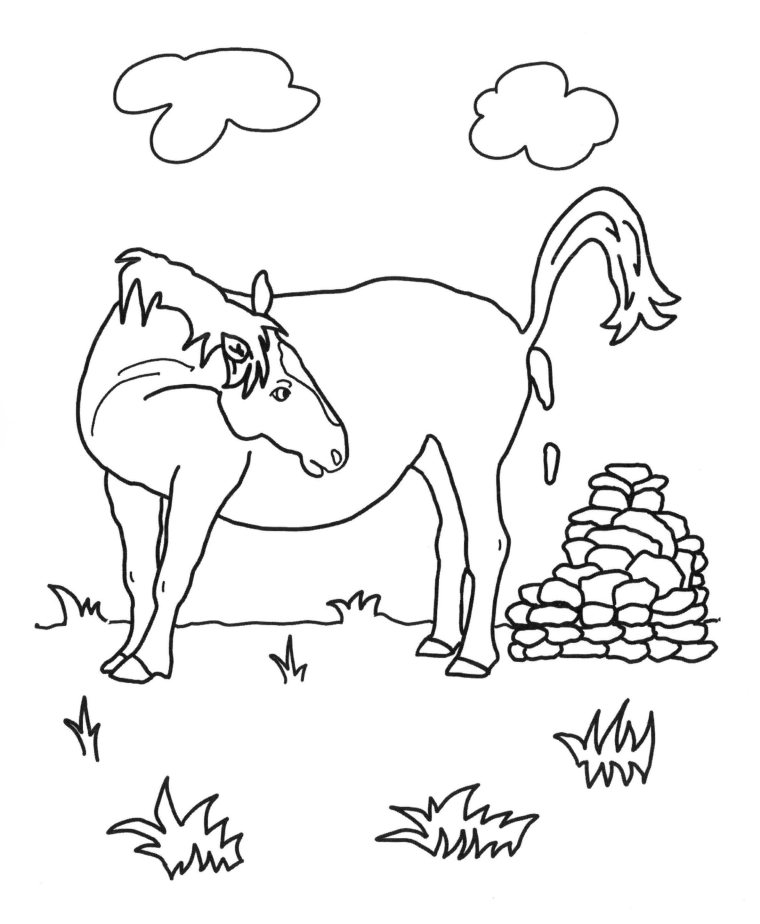

Lion poop is scary because everyone is afraid of it!

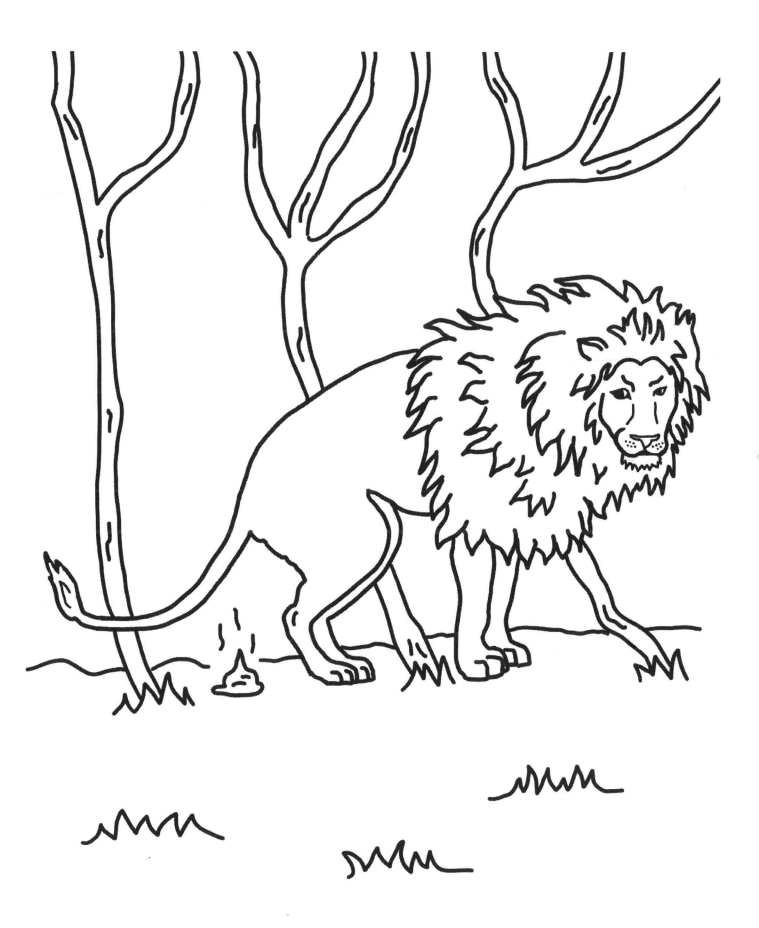

Alot of birds squirt their poop away from their nest or roosting area!

People make souvenirs out of moose poop!

Dried Buffalo Chips anyone?

Coyotes like to poop in the middle of the road!

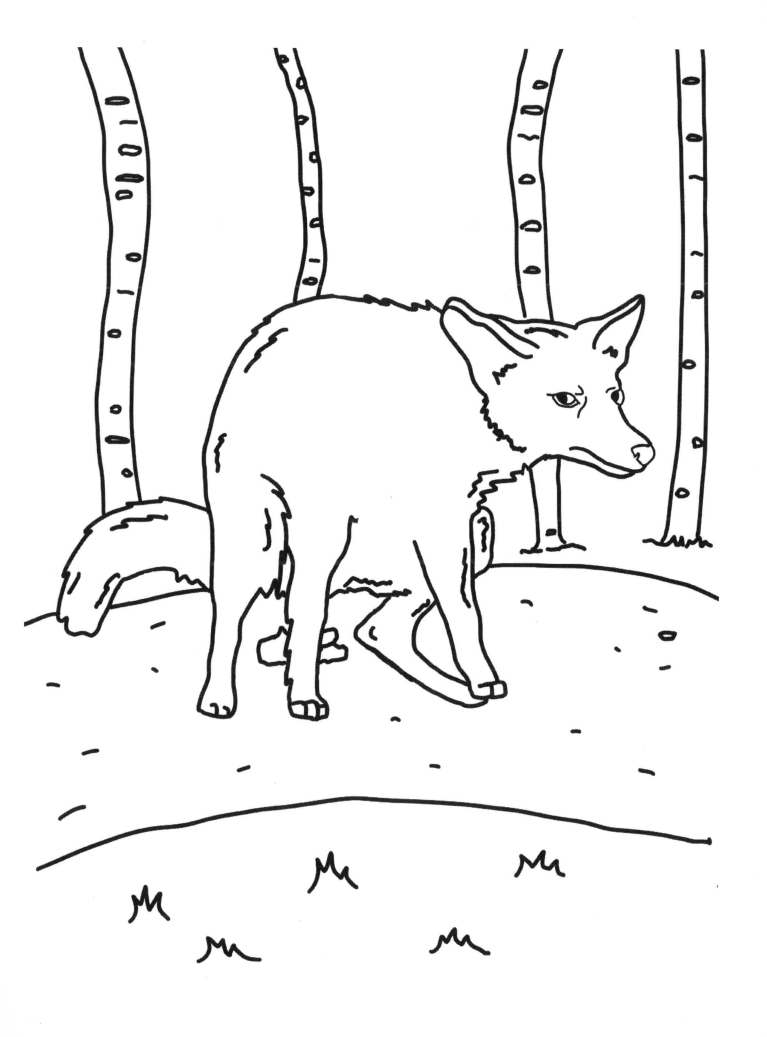

Burning cow dung keeps mosquitos away!

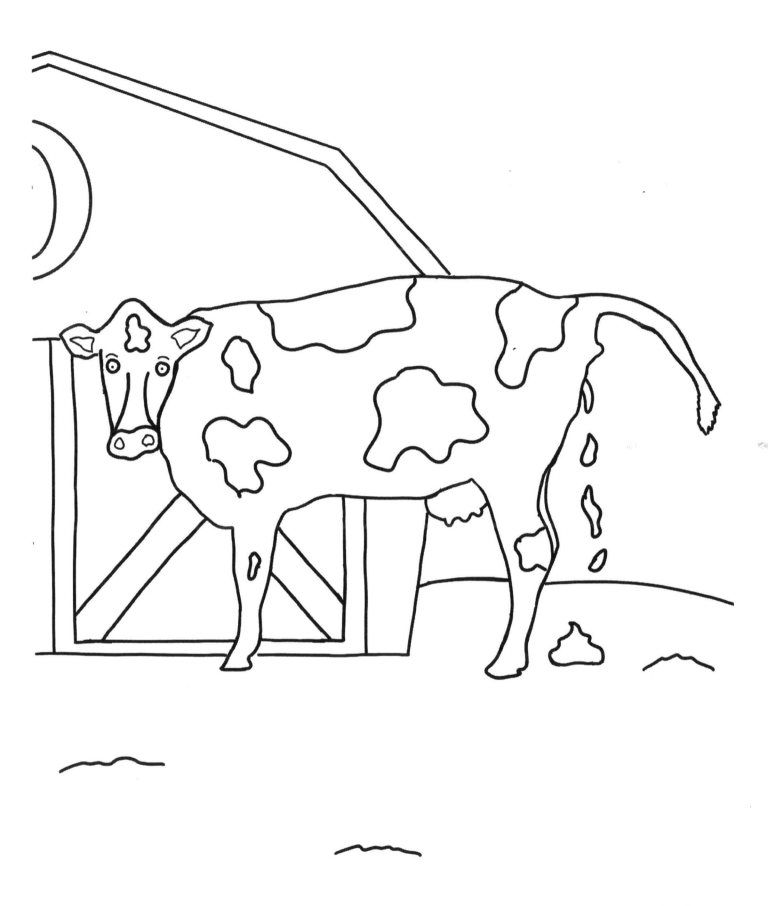

Camel poop is as dry as the desert!

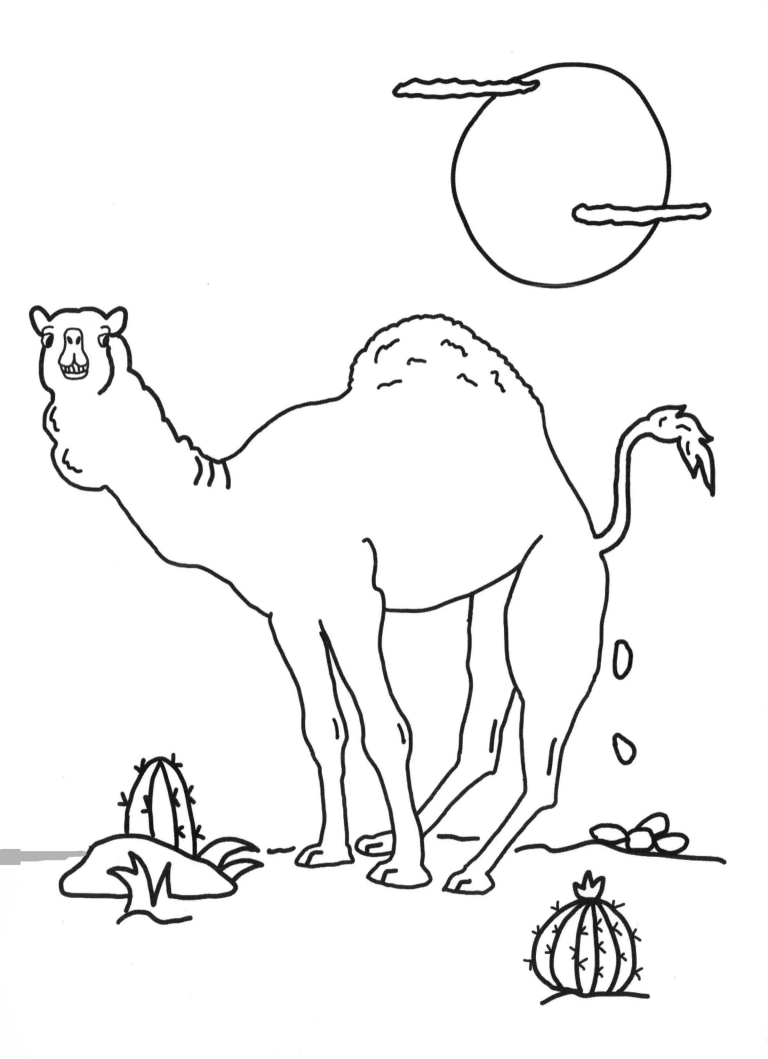

Imagine pooping in the same place every day?
That's what pronghorns do!

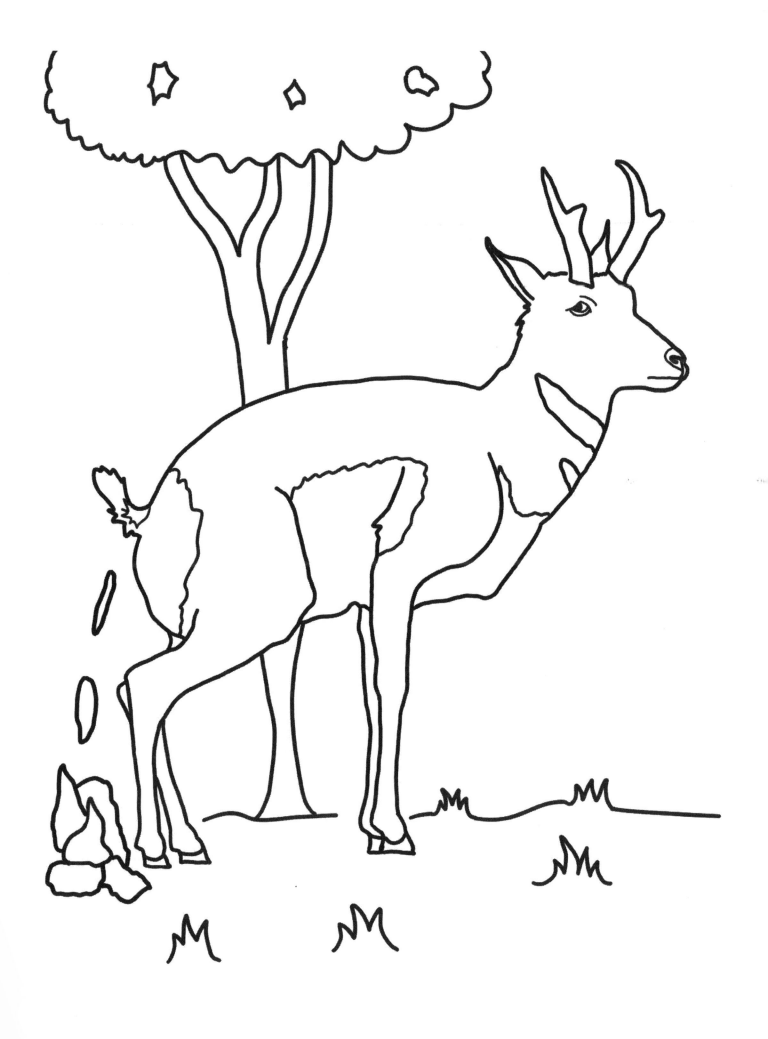

Rhinos like to stomp around in their poop, a whole new meaning in fashionable footwear!

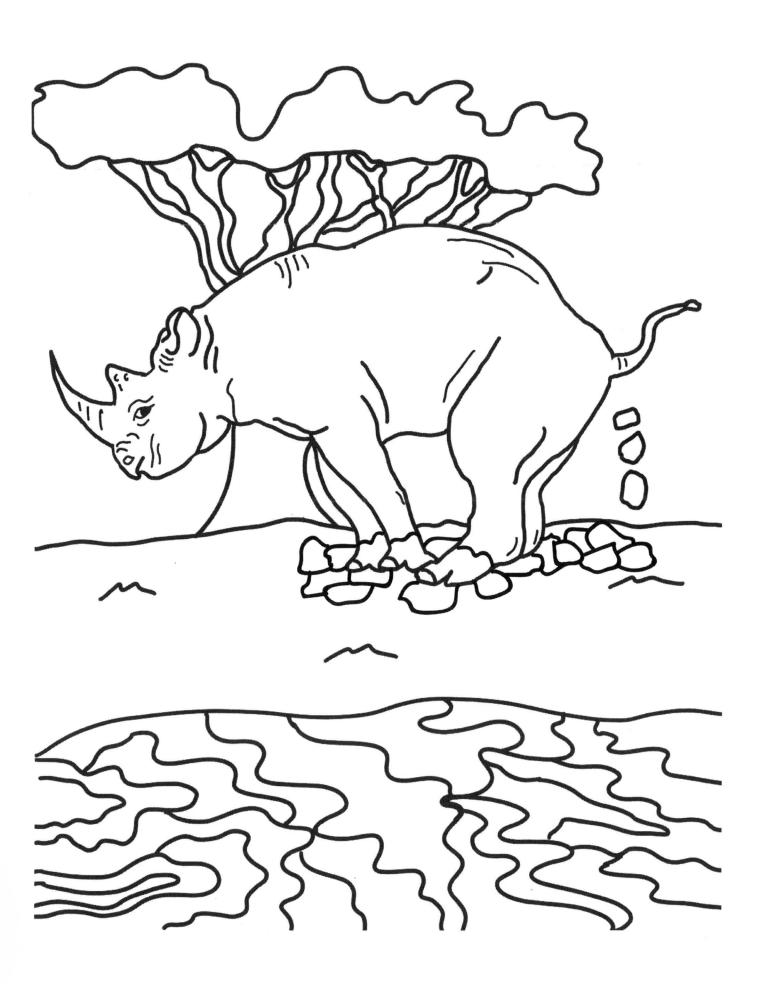

Phew, a Tiger's poop stinks for forty days!

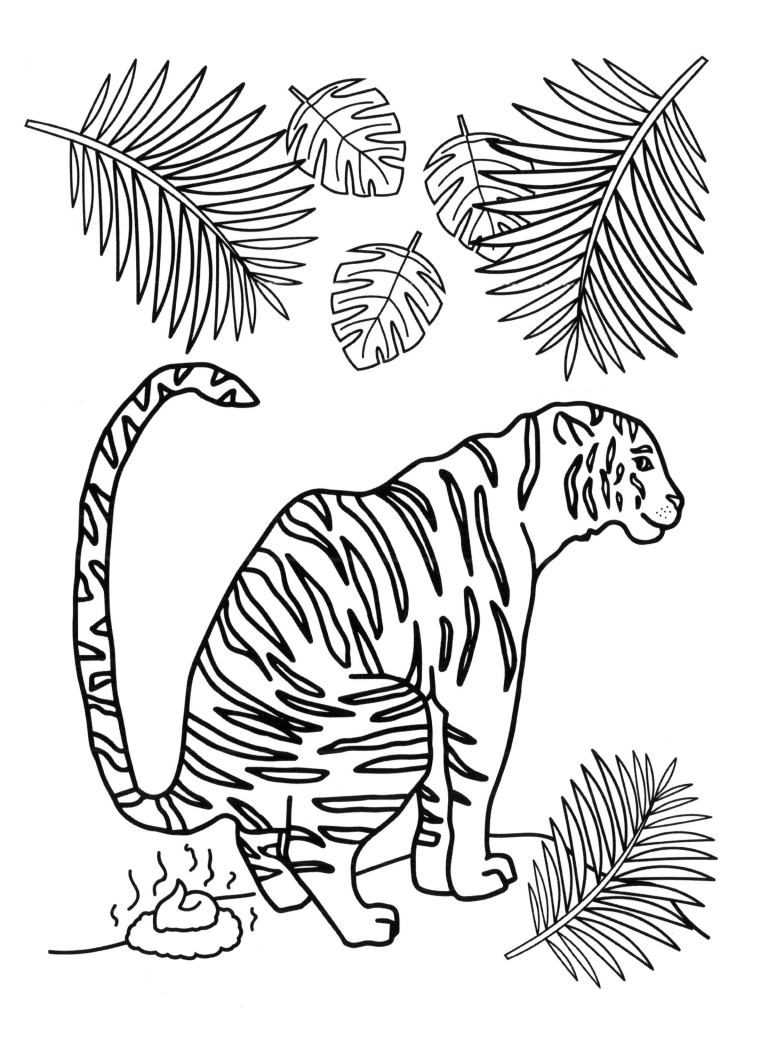

Also by:
WHAT THE FARCE

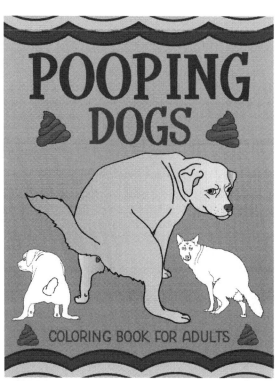

POOPING
DOGS
COLORING BOOK FOR ADULTS

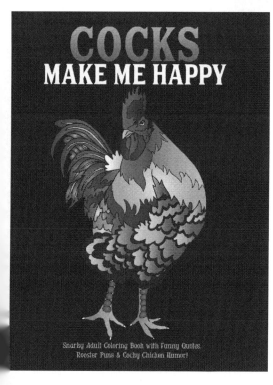

COCKS
MAKE ME HAPPY

Snarky Adult Coloring Book with Funny Quotes,
Rooster Puns & Cocky Chicken Humor!

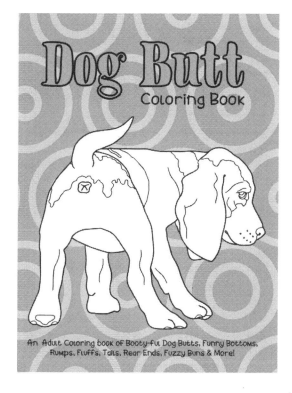

Dog Butt
Coloring Book

An Adult Coloring book of Booty-ful Dog Butts, Funny Bottoms,
Rumps, Fluffs, Tails, Rear Ends, Fuzzy Buns & More!

Made in the USA
San Bernardino, CA
17 December 2019

61702557R00038